P = P = E = D = A

NOTE TO PARENTS

This book is part of PICTUREPEDIA, a completely new kind of information series for children. Its unique combination of pictures and words encourages children to use their eyes to discover and explore the world, while introducing them to a wealth of basic knowledge. Clear, straightforward text explains each picture thoroughly and provides additional information about the topic.

"Looking it up" becomes an easy task with PICTUREPEDIA, an ideal first reference for all types of schoolwork. Because PICTUREPEDIA is also entertaining, children will enjoy reading its words and looking at its pictures over and over again. You can encourage and stimulate further inquiry by helping your child pose simple questions for the whole family to "look up" and answer together.

EARTH

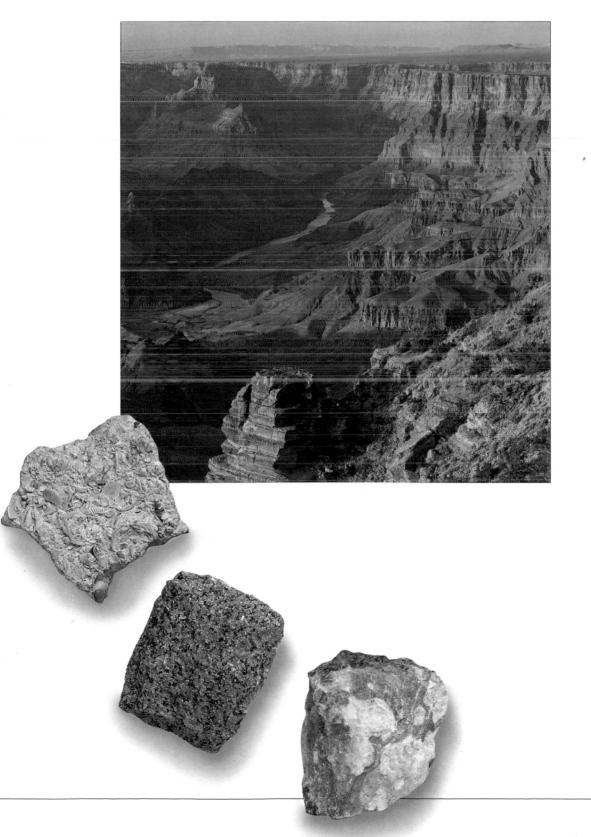

A DORLING KINDERSLEY BOOK Conceived, edited, and designed by DK Direct Limited

Consultant Chris Pellant

Editor Roz Fishel Art Editor Ron Stobbart Designer Tuong Nguyen

US Editor B. Alison Weir

Series Editor Sarah Phillips Series Art Editor Paul Wilkinson

Picture Researcher Paul Snelgrove Photography Organizer Alison Verity

Production Manager Ian Paton

Editorial Director Jonathan Reed **Design Director** Ed Day

First American Edition, 1992 10 9 8 7 6 5 4 3 2 Published in the United States by Dorling Kindersley, Inc., 232 Madison Avenue New York, New York 10016

Copyright © 1992 Dorling Kindersley Limited, London.

All rights reserved under International and Pan-American Copyright Conventions. No part of this publication may be reproduced, stored in a retrieval system, or transmitted in any form or by any means, electronic, mechanical, photocopying, recording, or otherwise, without the prior written permission of the copyright owner. Published in Great Britain by Dorling Kindersley Limited. Distributed by Houghton Mifflin Company, Boston.

Library of Congress Cataloging-in-Publication Data

Library of Congress Cataloging-in-Publication Data Earth / Chris Pellant, editor. – 1st American ed. p. cm. – (Picturepedia) Includes index. Summary: Explores different aspects of the Earth, including its crust, plates, rocks, oceans, deserts, and climate. ISBN 1-56458-138-1 1. Earth – Juvenile literature. 2. Geology – Juvenile literature. 3. Geophysics – Juvenile literature. [1. Earth.] I. Pellant, Chris. II. Series. QB631.4.E37 1992 550–dc20 92–52834 CIP

92–52834 CIP AC

Reproduced by Colourscan, Singapore Printed and bound in Italy by Graphicom

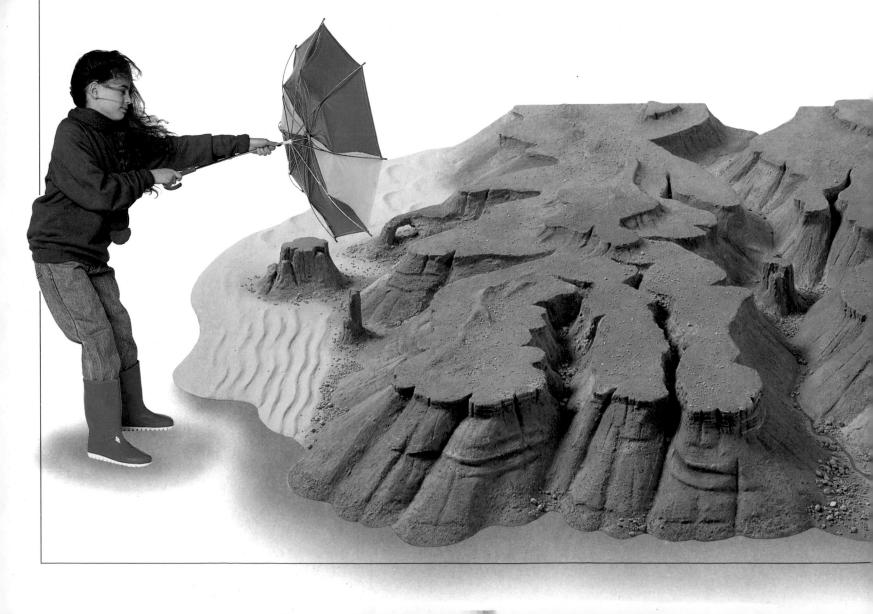

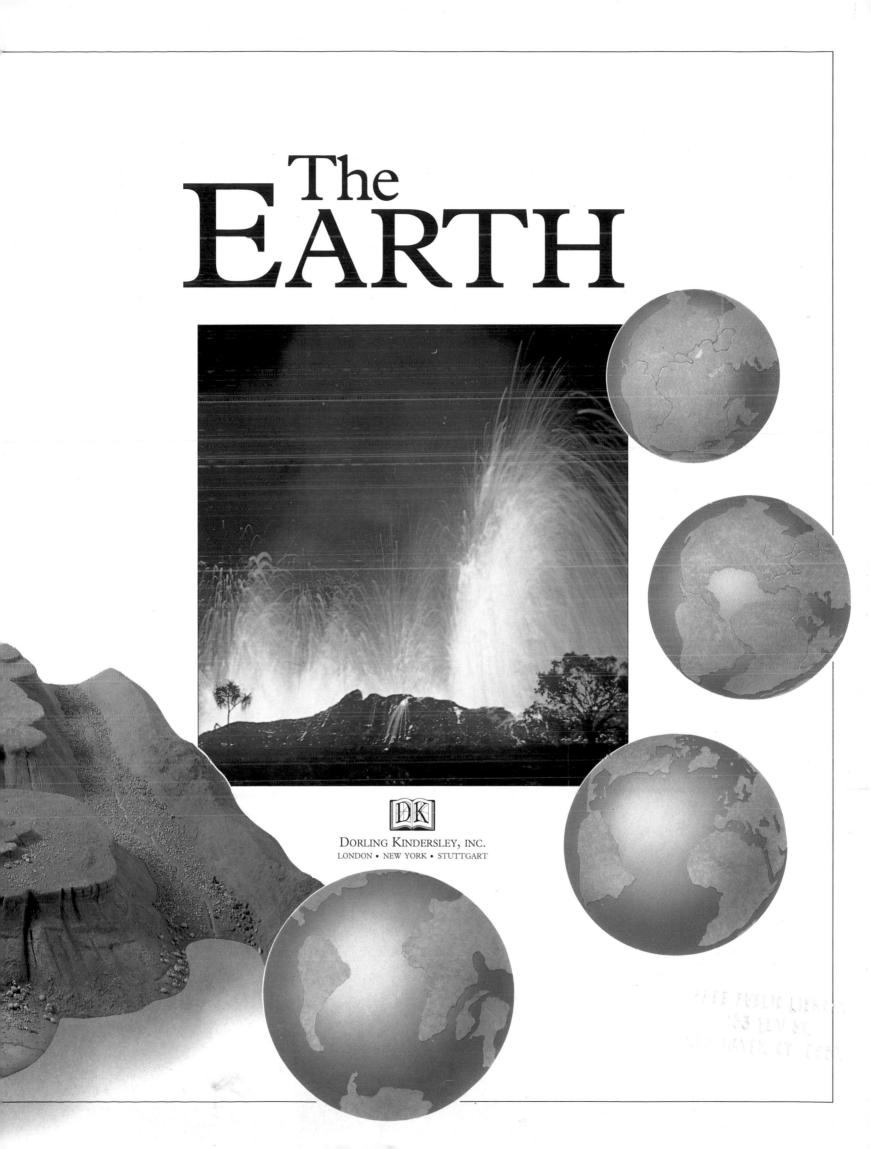

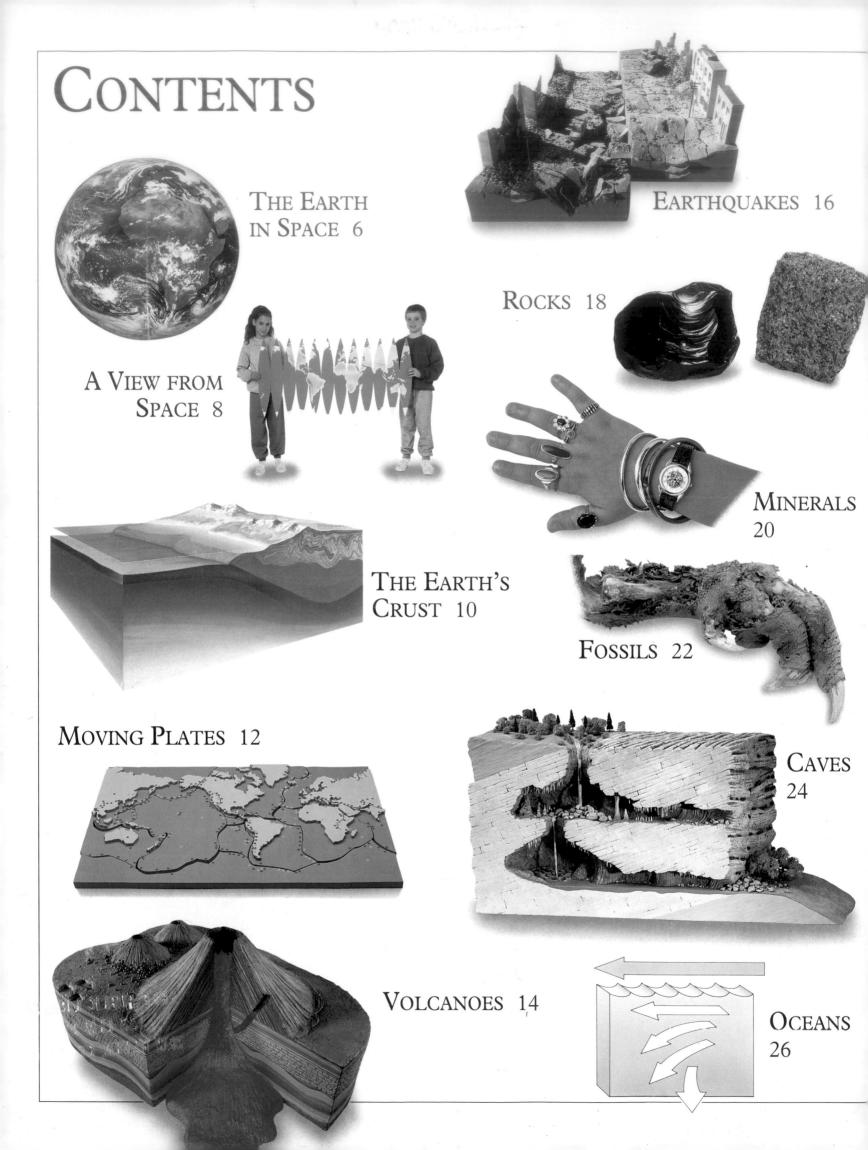

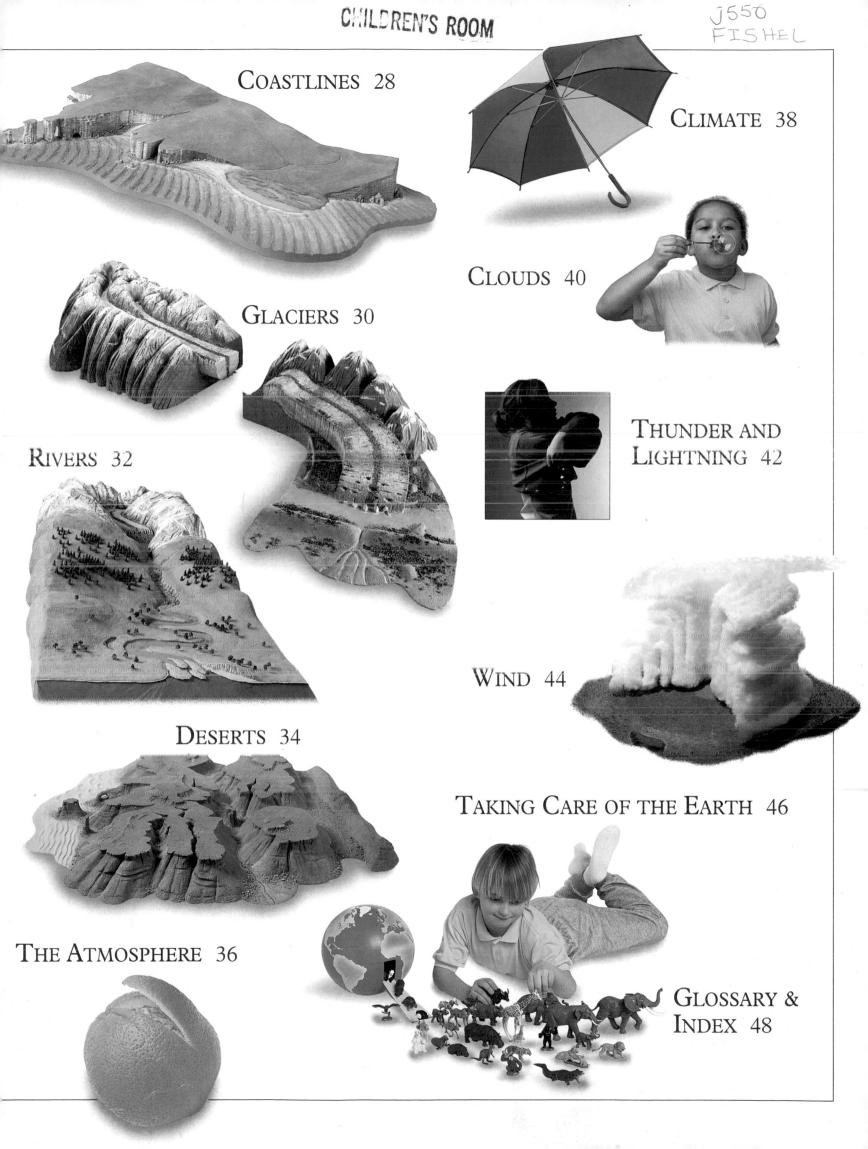

THE EARTH IN SPACE

Star Bright

The solar system belongs to a cluster of millions of stars and planets called a galaxy. Our galaxy is spiral-shaped and is called the Milky Way. It is so vast that a jet would take 100 billion years to fly across it.

Taking Measurements All the planets are different sizes. They are shown here in proportion to one another. Can you tell which is the largest planet and which is the smallest? Two of the planets are very similar in size. Can you pick out which ones they are?

THE SUN

To us, planet Earth seems enormous, but in the vastness of space it is only a tiny speck. It is one of the nine planets that hurtle continuously around a star – our Sun – in huge ellipses called orbits. Together, the Sun and planets are called the solar system. This, in turn, is part of a galaxy, one of the 6,000 million known ones that make up the universe.

like a star with Mars. a long tail.

Venus

Mercury

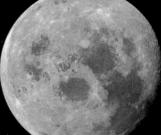

Asteroid

Different Worlds The Moon orbits the Earth. It is the Earth's satellite and neighbor, but it is totally lifeless. Humans first walked on the Moon in 1969.

URANUS

PLUTO

Pluto 3,666 million miles (5,900 M km)

Neptune 2,794 million miles (4,497 M km)

NEPTUNE

Uranus 1,740 million miles (2,800 M km)

Saturn 967 million miles (1,556 M km)

Jupiter 483 million miles (778 M km)

Mars 142 million miles (228 M km) Earth 93 million miles (150 M km)

Venus 67 million miles (108 M km)

Mercury 36 million miles (58 M km)

Farther and Farther

Each planet goes around the Sun on its own elliptical orbit. The distance of each planet from the Sun is enormous.

SATURN

The Sun is a burning ball of gases that gives both heat and light to our planet.Without it, the Earth would be a dead place. Solar flare, thousands of miles long

JUPITER

Putting On Weight

7

Did you know that the Earth is getting heavier every day? This is because particles of very fine dust, which are much too small to see, are landing on it from space. About 25 tons are falling on the planet every day.

> Sunspots are dark spots on the Sun showing areas that are cooler than the rest.

AVIEW FROM SPACE

Imagine you are an astronaut in space looking at the Earth through the porthole of your spacecraft. You see a big, blue ball that is always covered by swirling white clouds. The clouds make it hard for you to see the Earth in detail, but if they were not there, you would be able to see North America land, mountains, seas, ice, and rivers.

South America

Homing In Even small features can be seen from space. This photo shows London, England, in fine detail.

Greenland

North Pole.

Europe

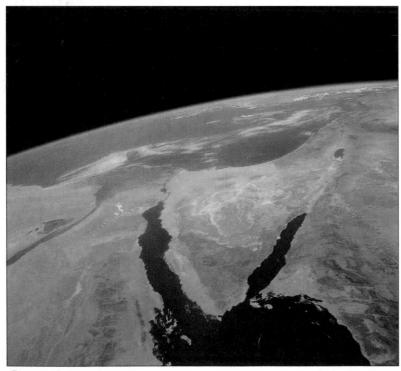

Grand Scale Parts of Egypt, Israel, Jordan, and Saudi Arabia are shown in this photo. You can see the Mediterranean Sea at the top and the northern part of the Red Sea at the bottom.

Antarctica

Africa

Atlantic Ocean

Why Is the Earth Blue? The Earth looks blue from space because more than two thirds of it are huge oceans and smaller seas. From some places in space, you would see mostly water and only a tiny amount of greenish land.

South Pole

Viewpoint

If you had been one of the crew of the space shuttle Columbia 6, this is how you would have seen the Himalayan Mountains as you circled the Earth.

> Himalayan Mountains,

Middle East

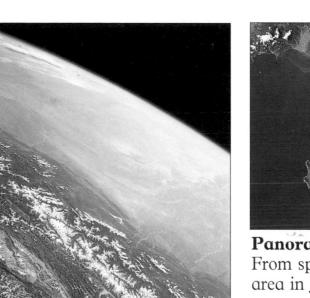

Pacific Ocean

Asia

Australia

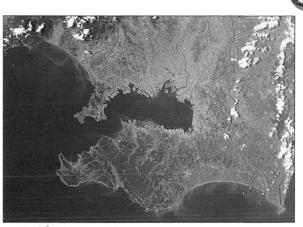

Panorama

From space, you are looking at the area in Japan that contains Tokyo.

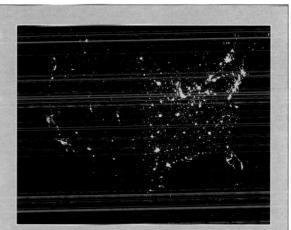

Lighting Up the Sky At night, the lights of cities show you where lots of people live. The black patches show deserts and mountains, which are mostly uninhabited, and oceans.

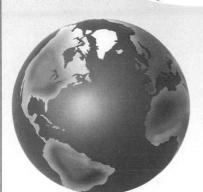

The Earth is round, like a ball. When a map is made, it is shown flat.

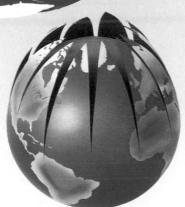

The best way to flatten out the Earth is to split it into pieces, like the segments of an orange.

The segments are laid flat. The gaps are then filled in to make the map an oblong shape.

How Maps Are Made

THE EARTH'S CRUST

The crust is a thin layer of rock between 3½ and 42 miles (5.6 and 67.6 km) thick.

The mantle is the layer below the crust. In parts of it, the rock has melted like butter.

Just like you, the Earth has a very delicate skin. It is so thin that if you compare it to the whole Earth, it is thinner than the skin of an apple.

The Earth's skin, or crust, is made up of rock, built up in layers over millions of years. The layers look like blankets on a bed, with lots of lumps The inn and bumps in them.

The outer core _ is made of iron and nickel that has melted to form a liquid.

The inner core is a ball of / iron and nickel. It is hotter here than at the outer core, but the ball stays solid.

How Mountains Are Made

Mountains are made when the Earth's crust is pushed up in big folds or forced up or down in blocks. The different shapes made are given different names.

Upfold

,Overfold

Downfold

The ocean is on top of the oceanic crust. The oceanic crust also runs underneath the continental crust.

Land is made out of the continental crust. It is thickest where mountains are found.

Under the oceans, the crust is as little as 3 ½ miles (5.6 km) thick, but under the continents, it is up to 42 miles (67.6 km) thick.

Fault

Block mountain

The mantle

Rift valley,

A Long Way to Go

Did you know that the deepest hole ever drilled into the Earth's crust is 7.8 miles (12.5 km) deep? To reach the center of the Earth, you would have to drill 500 times deeper. **Going Down**

This is a rift valley. It was made when a block of land sank down between two long breaks, called faults, in the Earth's crust.

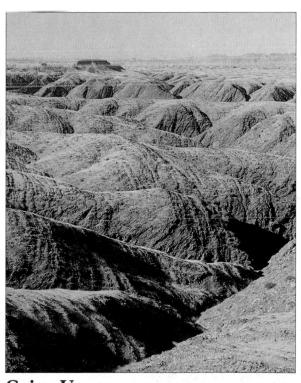

Going Up Here the land has been pushed into giant folds by movements in the Earth's crust. You can see how the crust is made up of many, many layers of rock.

The red dots show you the places where volcanoes erupt.

All Scrunched Up Sometimes, two plates push against each other and crumple the land,

making huge mountain

Going Down

ranges.

Sometimes, one plate slides under another. It is pushed down into the mantle and melts.

Doing a Split

Sometimes, two plates split apart, and lava bubbles up to fill the gap. It hardens and forms new land.

Slip-Sliding Away

Sometimes, two plates slip sideways past each other. This kind of movement causes earthquakes.

Continent,

On the Move

The plates move all the time. In one year, they will usually move about one inch (2.5 cm). That's about as much as your fingernails grow in the same amount of time.

Past, Present, Future

Have you ever wondered what the Earth looked like in the past? These pictures show you how the continents have moved over the last 300 million years, and how the world may look 50 million years from now.

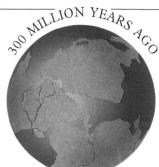

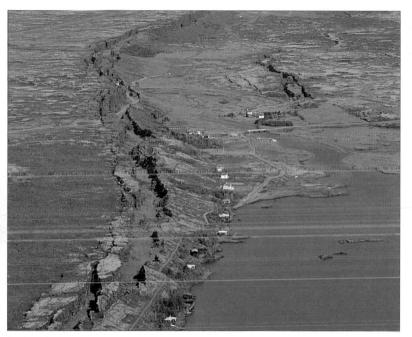

The Restless Earth These houses and roads in Iceland are near a spot where two plates meet and have split the land.

The green dots show you the places where earthquakes occur. This is where two plates meet **Changing Places** The land is coming together

to make one gigantic continent.

200 MILLION YEARS YCG

All Together The super continent has come together. We call it Pangaea.

150 MILLION YEARS ACO

LAURASIA

Worlds Apart The land is drifting apart again. Pangaea is splitting into two parts: Laurasia and Gondwanaland.

GONDWANALAND

TODAY

Familiar Ground

Today, the world looks like this – but the continents are still moving.

NILLION YEARS FROM NOL

Looking Ahead

This is how the world may look 50 million years from now. Can you spot how the land has changed its shape? To get started, find Africa on the globe and see how it has joined up with Europe.

VOLCANOES

When you shake up a can of soda and then pull off the tab, the contents shoot out with a whoosh! A volcano acts a bit like this. With tremendous force, molten rock bursts through weak parts in the Earth's crust and is hurled high into the sky.

Volcanoes can be quiet and not erupt for a long time.

Hot springs are often found near volcanoes.

Nature's Fireworks

This volcano is putting on its own spectacular fireworks display. The explosions of red-hot lava and ash from the crater look like gigantic Roman candles.

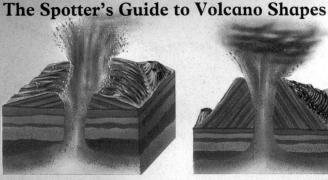

Spreading Out Some volcanoes are flat. Their lava is very runny, so it spreads out in a thin sheet.

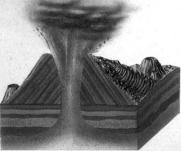

Short and Plump Some volcanoes are squat. They are made of ash, which is lava that has turned to dust.

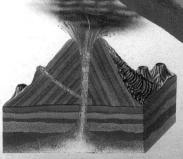

Going Up Some volcanoes have pointed cones. Their lava is thick and sticky so it does not run far.

River of Fire

The red-hot molten rock that is streaming down the sides of this volcano is beautiful but deadly. It is so hot that it can melt steel.

Clouds of ash and gas pour out from the crater.

Molten rock, called magma, rises up the main pipe and any branch pipes.

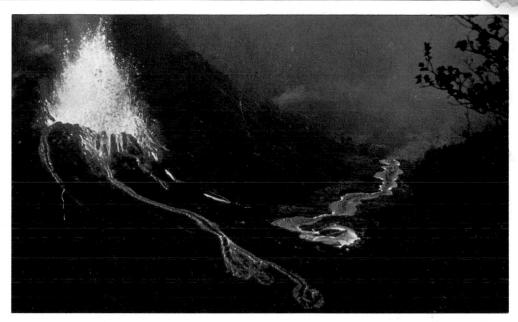

A volcano builds up from layers of ash and lava. **Mixed Bunch** When lava cools and hardens, it can make rocks with different shapes. Here are three types:

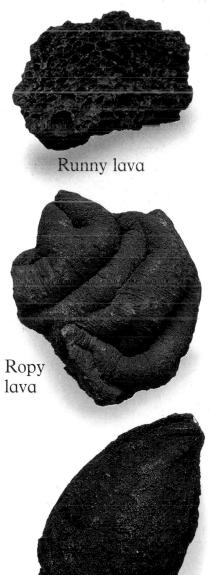

Magma collects in a chamber found deep underground. It is forced up through cracks and holes in the ground.

A volcanic "bomb"

EARTHQUAKES

Our planet is a restless place. Every 30 seconds, the ground suddenly rumbles and trembles. Most of the movements are so slight that they are not felt. Others bring complete disaster. Big cracks appear in the land, streets buckle, and buildings crumble. Whole towns and cities can be destroyed. Then everything settles down but is totally changed. The Earth has shaken. An earthquake has happened.

Fires are started by broken gas pipes and broken electrical cables.

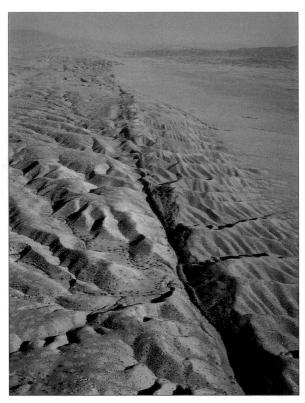

Unsafe Ground This is the San Andreas Fault in California. Earthquakes regularly happen here.

Terror from the Sea

Earthquakes under the ocean can cause giant, destructive waves called tsunamis, or tidal waves. Cars are smashed and they settle at crazy angles.

telephone lines

Fallen

On this side of the fault the land has moved toward you.

16

An earthquake occurs along a fault in the seabed.

Tsunamis can travel many miles across the ocean.

Why Earthquakes Happen

You may think that your feet are firmly on the ground, but the Earth's crust is moving all the time. It is made of moving parts called plates. When the plates slide past or into each other, the rocks jolt and send out shock waves.

Shaken Up

The Mercalli Scale measures how much the surface of the Earth shakes during an earthquake. There are 12 intensities, or grades. At intensity 1, the effects are not felt, but by intensity 12, the shock waves can be seen and there is total destruction.

What To Do in an Earthquake

Indoors, lie down under a bed or heavy table, or stand in a doorway or a corner of a room. After a minute, when the tremors will usually have finished, go outside, away from buildings, to a wide-open space.

Earthquake Words

The place within the Earth where an earthquake starts is called the focus. The earthquake is usually strongest at the epicenter. This is the point on the Earth's surface directly above the focus. The study of earthquakes and the shock waves they send out is called seismology.

Destructive Force

A tsunami piles up and gets very tall before it crashes onto the shore. It is so powerful that it can smash harbors and towns and sweep ships inland.

Fault line

On this side of the fault the land has moved away from you.

17

A tsunami can be almost 200 feet (61 m) high and can travel as fast as a jet.

ROCKS

Movements in the Earth's crust are slowly changing the rocks that make up the surface of our planet. Mountains are pushed up and weathered

away. The fragments are moved and made into other rocks. These rocks may be dragged down into the mantle and melted by its fierce heat.

When a volcano erupts, the melted rock is thrown to the surface as lava, which cools and hardens as rock. This is broken down by weathering, and so the cycle starts again.

Conglomerate

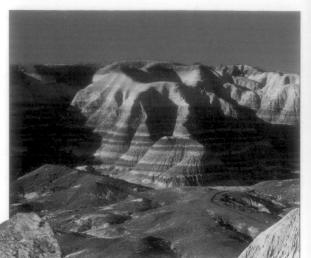

Sedimentary Rocks These are made from bits of rock and plant and animal remains. They are broken into fine pieces and carried by rivers into the sea. They pile up in layers and press together to make solid rock. The Painted Desert in Arizona is made of sedimentary rocks.

Red sandstone

Limestone

In the Beginning

Rocks belong to three basic types. Igneous rocks are made from magma or lava and are also known as "fiery" rocks. Sedimentary rocks are made in layers from broken rocks. Metamorphic rocks can start off as any type. They are changed by heat and weight and are called "changed form" rocks.

In time, material moved by rivers and piled up in the ocean will become sedimentary rocks. Rock fragments are carried from one place to another by rivers, glaciers, the wind, and the sea.

Recently formed sedimentary rocks

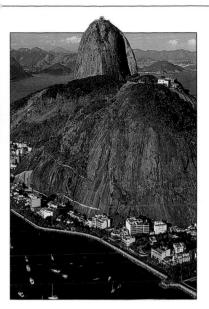

Igneous Rocks

These are made from magma or lava. It cools and hardens inside the Earth's crust or on the surface when it erupts from a volcano. Sugar Loaf Mountain in Brazil was once igneous rock under the crust. The rocks above and around it have been worn away.

Obsidian

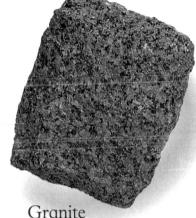

Surface rocks are broken down by the weather and by the scraping effect of tiny pieces of rock carried in the wind or in the ice of glaciers.

Metamorphic Rocks These are igneous or sedimentary rocks that are changed by underground heat, underground weight, or both. This marble was once limestone, a sedimentary rock. It was changed into marble by intense heat.

> Some rocks are thrust up as mountain ranges when the crust moves and makes giant folds.

Volcano,

Marble

Slate

Molten rock that cools and hardens inside the Earth is called intrusive igneous rock.

Metamorphic rocks,/ formed by heat and pressure

Glacier.

Lava that erupt's from a volcano forms extrusive igneous rock.

Folded rocks

Magma

19

MINERALS

Every time you put salt on your food, use a pencil, sprinkle yourself with

talcum powder, or tell the
time by a quartz watch,
you are using minerals.
Minerals make up rocks,
but we adapt them to make
all sorts of things that we use
in our everyday lives.

Quartz

Rock Builders

Minerals are the building blocks of rocks. Some rocks are made up of only one mineral. Others contain many

of them. If you look at granite, for example, you will see that it is made of quartz, feldspar, and mica.

100

Talc

Gypsum

Granite

Hard, Harder, Hardest

Some minerals are soft. Some are hard. This scale of hardness goes up in ten steps, starting with the softest mineral, talc, and ending with the hardest, diamond. It is called Mohs Scale after the person who invented it in 1812. Hematite, an iron ore

A steel screw

Liquid Rock

Did you know that the liquid mercury that is used inside a thermometer was once hard? Mercury is an ore found in rock. It melts very easily and becomes runny.

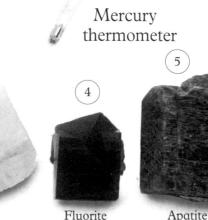

Crystals

are shown here.

Minerals that contain

metals are known as ores. Hematite is an

important iron ore that is

Feldspar

Mercury ore

Most minerals come in the form

of crystals. Crystals can be many

Ores

used to make steel.

different shapes and sizes. Some of them

Orthoclase

Calcite

Mica

Beautiful and Rare

Gold and silver are precious metals that are found in rocks. They are prized for their beauty and rarity and both of them are used to make jewelry.

Veins of gold in quartz

> Sapphire and diamonds Lapis lazuli

Silver

Carnelian.

Gems

7

Quartz

Gems are rare and precious minerals that arc mainly used to make jewelry. Diamonds, emeralds, rubics, sapphires, and opals are all well-known, valuable gems, but many lesser-known minerals are also used.

Blue agate.

8

Topaz

9

Smoky quartz_

((A))

The Cutting Edge

small pebbles of cloudy glass. Their sparkle and shine show only when they have been cut and polished.

On the Mend The plaster used to set a broken limb is made from a mineral that is called gypsum.

-.Onyx

Turquoise

Gold

Silver

Malachite

_Quartz watch

Corundum

Diamond

10

21

FOSSILS

Are you a detective who wants to find out what life on Earth was like millions of years ago? If your are, your best clues are fossils. Fossils are the remains or evidence of animals and plants saved in stone, peat, ice, or tar. They may be as large as a dinosaur

skeleton or as small as a grain of pollen that can be seen only under a microscope.

Fossil in the Making

A dead animal may be covered with sand or mud in a lake, river, ocean, or on land.

The rock is folded and pushed up. Wind and rain wear away the top layers. The sand or mud hardens into rock. The bones of the animal are preserved in the rock as a fossil.

The fossil is uncovered when the top layers of rock wear away.

Back from the Past

When Mount Vesuvius erupted over Pompeii, this dog's body left a hollow in the ash that hardened around it. When plaster was poured into the hollow, the dog's shape was recreated.

Birdlike tracks from the dinosaur called Allosaurus

Reading the Signs

The Allosaurus hunted other dinosaurs for food. Because there are two sets of footprints overlapping each other, the Allosaurus may have been tracking the Apatosaurus to kill and eat it.

Allosaurus

Amazing Finds These very different

in layers of rock.

items were all fossilized

Fish

Apatosaurus

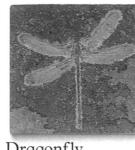

Dragonfly

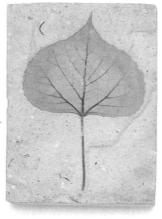

Poplar leaf

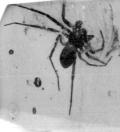

Caught in Time This spider was trapped in resin, a sticky liquid that dripped down the trunk of an ancient pine tree. The resin hardened into amber.

Skin and Bones

The tossilized foot of this giant extinct bird, called a moa, still has skin attached. You can see how big the foot is by comparing it to a child's hand.

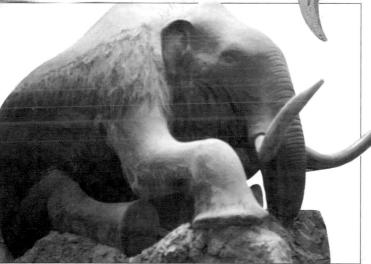

These large footprints belong to an Apatosaurus and are about 3 feet (1 m) across.

Deep Freeze

This mammoth was frozen in ice at least 12,000 years ago. It may have been trapped in a swamp. When the swamp froze, the mammoth's body was preserved in the ice.

Power from the Past Did you know that coal and oil are called fossil fuels? They are made from plants or animals that lived and died millions of years ago.

23

CAVES Caves are hollows beneath the surface of the Earth. The biggest ones are all found

the Earth. The biggest ones are all found in rock called limestone, and some are huge. The world's biggest cave, in Sarawak in Borneo, is so large it could fit 800 tennis courts in it. Yet these caves began simply as cracks or holes in the rock that, over thousands of years, were made bigger by rainwater trickling into them and eating them away.

Going Down

Water dripping from the ceiling of a cave leaves behind a mineral called calcite. Very slowly, this grows downward in an icicle shape that is called a stalactite.

The stream disappears underground into a pothole.

This pothole, or tunnel, leads straight down through the rock. It was made by a stream wearing away the rock.

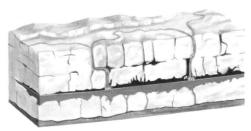

Drip . . .

The rainwater that seeps into the ground is very slightly acid and begins to eat away the limestone.

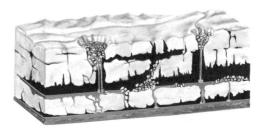

Drip . . .

The rainwater eats through the rock. It widens the cracks into pits, passages, and caves.

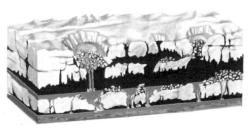

Drip

Over thousands of years, the passages and caves may join up to make a huge underground system.

Limestone is a very common rock. It is made from the skeletons and shells of tiny sea creatures that died millions of years ago.

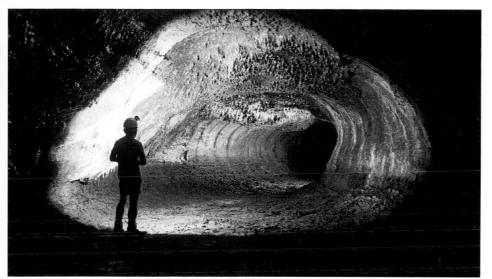

Tunnel of Lava

Caves are found in rocks other than limestone. This one is made of lava and is inside a volcano in Hawaii.

Cracks in the rock are widened when rainwater seeps along them.

Limestone pavements are made when the rock is eaten away along joint lines.

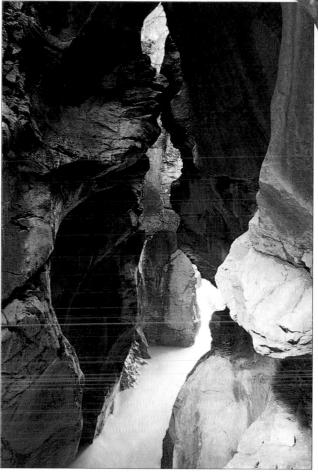

Caving In

Sometimes a cave may be turned into a gorge. This happens when the roof falls in and reveals the caverns and galleries that are hidden underground.

Cliff

Gallery

,Cave mouth

Stream

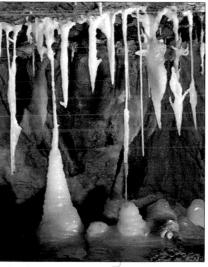

Going Up Where water drips onto the cave floor, columns of calcite, called stalagmites, grow upward.

OCEANS

More than two thirds of our planet is covered with water, and oceans make up 71 percent of the Earth's surface. Beneath the waves lies a fascinating landscape. Much of the ocean floor is a vast plain, but there are also cliffs, trenches, and mountain ranges, all larger than any found on dry land.

Ocean Currents

These show the directions in which water flows.

Atlantic Ocean

Pacific Ocean

Cold currents

Warm currents

Underwater canyons are cut by currents flowing over the seabed like rivers., These underwater islands are called guyots. Earth Moon **Ebbing and Flowing**

Sun

Tides are made by the Sun and Moon pulling on the oceans. When the Sun, Earth, and Moon are in a line, there are large spring tides.

Trenches can be deeper than the highest mountains on land.,

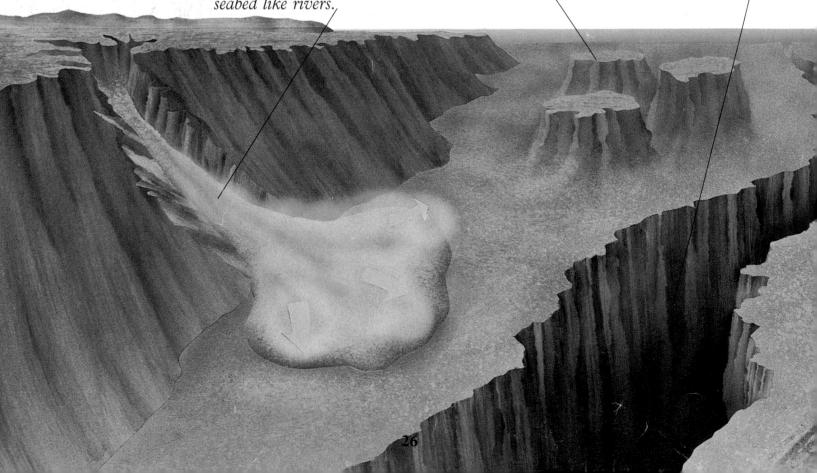

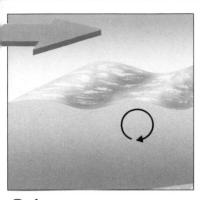

Going . . . The water inside a wave moves around and around in a circle. It is the wind that drives the wave forward.

Ocean Currents

The direction in which currents move depends on winds and the Earth's spin. Winds blow the top of the oceans forward, but the Earth's spin makes the water below go in a spiral.

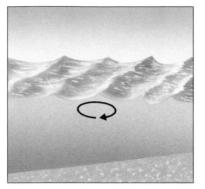

Going... Near the shore, the circular shape of the wave is changed, and it becomes squashed.

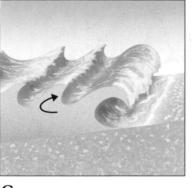

Gone

The top of the wave becomes unstable. When it hits the beach, it topples and spills over.

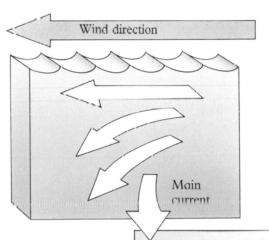

Lighted zone 660 feet (200 m)

Deepest zone, a trench of 36,300 feet (11,064 m)

Dark zone 20,000 feet (6,096 m)

The Dark Depths

Even in clear water, sunlight cannot reach very far. The oceans become darker and darker the farther down you go – until everything turns inky black.

This island is a volcano that has crupted from the ocean floor.

A long, wide ocean ridge_,

Water, heated by the hot rocks, shoots back into the sea.

Molten rock rises up, cools, and forms new seabed.

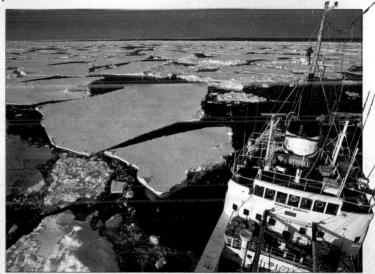

Frozen Worlds In Antarctica and the Arctic, the oceans freeze. Icebergs break away from glaciers flowing into the water. Only a tiny part of an iceberg is seen above the surface of the ocean.

Surface

COASTLINES

Have you ever built a sand castle and then watched the sea come in, knock it down, and flatten it? This is what happens to the coastline, the place where the land and the sea meet. The coastline changes all the time because, every few seconds of every day, waves hit the land and either wear it Some waves carry sand and pebbles from one area of the coast and leave them at another. This forms a new beach.,

Headland

away or build it up into different shapes.

A stack

An arch.

Going, Going, Gone

When caves made on both sides of a headland meet, an arch is formed. If the top of the arch falls down, a pillar of rock, called a stack, is left.

A cave forms over thousands of years as seawater creates cracks and holes in a cliff and makes them bigger.

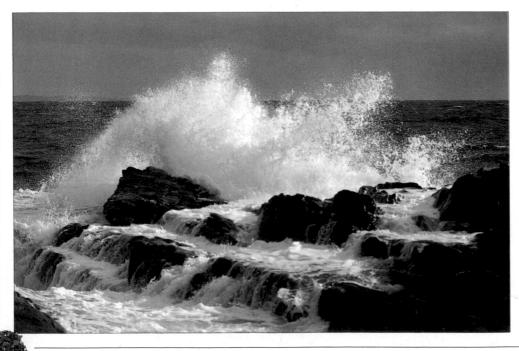

Some beaches are made in bays between headlands where the water is shallow and the waves are weak.

Pounding Away

Waves pound the coastline like a giant hammer until huge chunks of rock are broken off. The chunks are then carried away by the sea and flung against the coastline somewhere else.

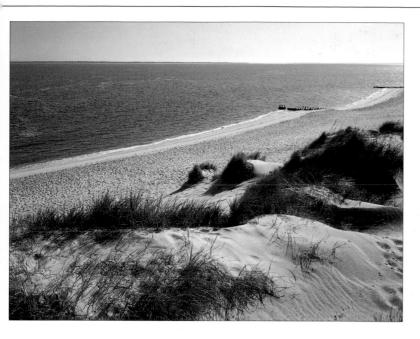

From Rocks to Sand Waves roll rocks and boulders backward and forward on the shore. The boulders break into pebbles and then into tiny grains of sand. This change takes hundreds or thousands of years.

Shifting Sands Dunes are made of sand blown into low hills by the wind.

An estuary is the place where a river flows into the sea.

Sea cliffs are one of the best places to see the different layers of rock.

Mud flats and marshes

Waves can build sand, mud, and pebbles into a long strip of new land, called a spit.

Living Rock

Coral is found in warm, sunny, shallow seas. It is made by tiny sea creatures that look like flowers. Over thousands of years, their skeletons build up into huge coral reefs and islands.

Glaciers begin as huge snowfields.

GLACIERS

Mountains,

A glacier is a huge river of ice that starts its life as a tiny snowflake. As more and more snow falls and builds up, in time it gets squashed under its own weight and turns to ice. A glacier moves very slowly downhill. Because it is very heavy, it can push rock along like a bulldozer. It can wear away the sides of mountains, smooth off the jagged bits from rocks, and move giant boulders over tens of miles.

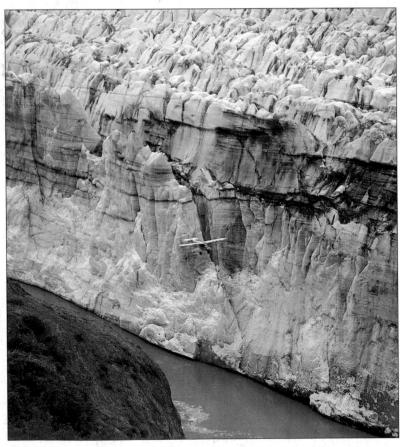

Close-Up View The pilot in this plane is watching a wall of ice break away from a glacier and begin to crash into the water below.

The snow collects in/ hollows and turns to ice under its own weight.

> Glaciers usually move/ downhill very slowly – no more than an inch or two (2.5 or 5 cm) a day.

The ice begins to move and rub away the sides and bottom of the hollow. Little by little, it changes the shape of the land and makes it into a U-shaped valley.

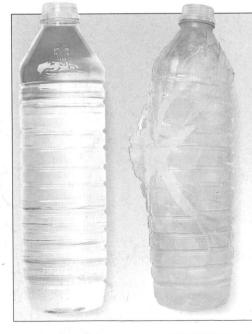

Ice Power

When the water in this bottle freezes and turns to ice, it takes up more room and breaks the bottle. When the water that makes up the ice of a glacier freezes, it takes up more room and pushes away the rock. ,Rubble is carried along by the glacier.

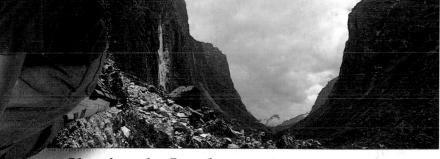

Shaping the Land

When you see a valley like this, you can tell from its U shape that it was once filled with the ice of a glacier.

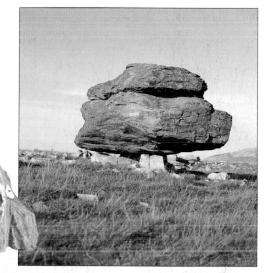

Out of Place

This giant boulder of hard rock was moved by a glacier and left on soft limestone. Then most of the limestone was weathered away, leaving a small block under the boulder.

> Where a glacier flows into water, chunks of ice break off and float away.

When the glacier melts, it makes new rivers.

Melted ice flows as streams and rivers inside most glaciers.

Bumps in the rock can be smoothed out by the ice moving downhill.

Rocks carried along by the glacier pile up when the glacier starts to melt and stops pushing them.

The lower end of the glacier is called the "snout."

RIVERS

Rivers are very powerful, so powerful that the force of the moving water is able to change the shape of the land. As they flow through mountains and over plains, rivers carry away huge amounts of rock, sand, and mud. They then dump it somewhere else, usually on riverbanks or in the ocean, to make new land.

A river usually begins in mountains or hills. Its water comes from rain or melted snow.

Glacier

Oxbow lake

Where the rock is hard, the river makes rapids or waterfalls.

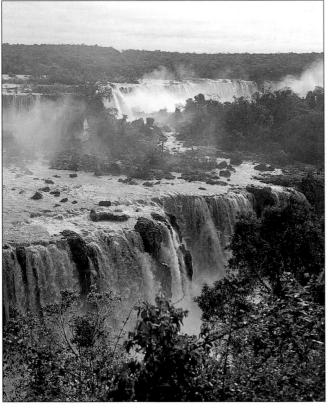

Over the Top

When a river tumbles over the edge of a steep cliff or over a hard, rocky ledge, it is called a waterfall. This one is in Brazil, South America.

> As the river flows quickly down steep/ slopes, it wears away the rock to make a V-shaped valley.

> > Sand, mud, and gravel are _____ left by the water as sediment.

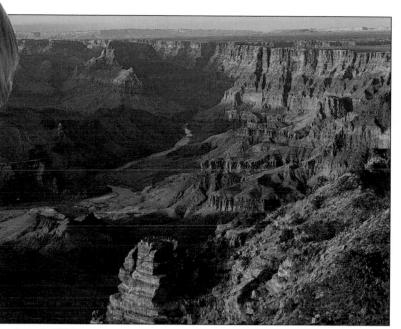

River Deep

In the USA, the waters of the Colorado River have carved out the largest gorge in the world. It is called the Grand Canyon. It is 1 mile (1.6 km) deep in some areas and 218 miles (350 km) long.

Around the Bend

When a river reaches flat land, it slows down and begins to flow in large loops. It leaves behind sand, gravel, and mud, called deposits. This changes the river's shape and course.

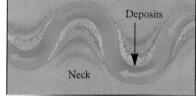

The river leaves deposits on the inside bend and eats away the outer bend.

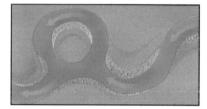

The deposits change the shape of the bend. In time, the neck of the bend narrows and the ends of the neck join up.

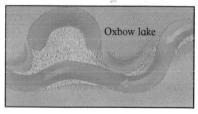

The river leaves behind a loop. It is called an oxbow lake because of its shape.

Record Rivers

The longest river in the world is the Nile, in Africa. It is 4,160 miles (6,690 km) long. The largest delta covers 30,000 square miles (77,700 km²). It is made by the Ganges and Brahmaputra Rivers, in Bangladesh and India.

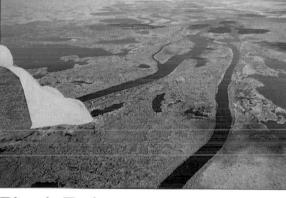

River's End This swampy land is part of the Yukon Delta in Alaska.

A wide bend or meander goes across flat country.

> As it reaches the ocean, the river divides into small streams to make a delta.

DESERTS

Did you know that deserts come in many different forms? They can be a sea of rolling sand, a huge area of flat and stony ground, or mountainous areas of shattered rock. There are hot deserts and cold deserts. So what do these very different areas have in common?

> The answer is that they are all very dry, and they all get less than 10 inches (25 cm) of rain each year. This rain may not fall regularly. Instead, it may all come in a single day and can cause a dramatic flash flood.

> > Cuesta_

Natural rock arch

Chimney or, pipe rock

Sea of Sand A desert may be hard to live in, but it can be stunning to look at. These dunes are in Saudi Arabia.

Mesa

Seif dunes

Tail dune

Barchan dunes

Wind

Star dunes

Wind Power Wind blows the sand into hills, which are called dunes. These have different shapes and names.

Butte Dunes

On the Move

Imagine your hair dryer is the wind. It blows sand up the gentle slope of the dune. When the sand gets to the top, it tumbles down the steep slope. As more and more

sand is moved from one slope to another, the whole dune moves forward.

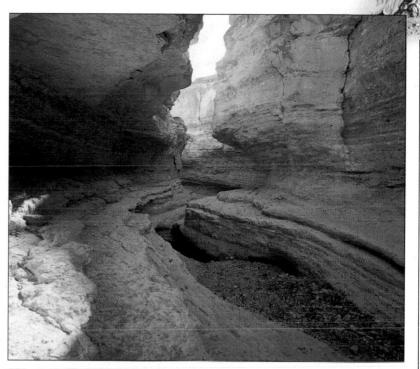

Heavy rain makes flash floods. These rush over the land, loaded with sand and stones, and cut deep channels in the surface of the desert.

Broken rocks slide downhill and collect in gullies.

Water Power The tremendous power of water has made this deep ravine near an oasis in Tunisia.

Where the rock is hard, ridges will stand out in the landscape.

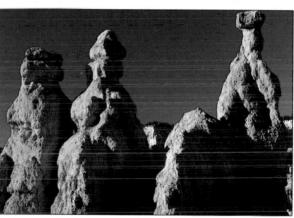

Shaping the Land Wind-borne sand blows against the rocks and wears them into beautiful and surprising shapes.

Steep slopes of broken rock

Outwash fan

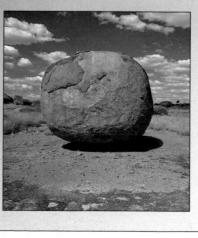

Hot and Cold This is one of the Devil's Marbles in the Northern Territory, Australia. The rock's outer layers have started to peel off because of the desert's very hot and very cold temperatures.

THE ATMOSPHERE

Around our planet there is a blanket of gases called the atmosphere. It is so thin that compared to the whole Earth, it is only as thick as the peel of an orange. Yet without this

blanket, life on Earth would be impossible. The atmosphere protects us from being roasted by the Sun and frozen by the cold of outer space. It contains the air we need to breathe and makes the rain that provides the water we need to drink.

> The troposphere contains most of the gases in the atmosphere and reaches about 7 miles (11 km) above us. This is where the weather occurs.

> > Above the troposphere is the stratosphere, which goes from 7 to 30 miles (11 to 48 km) above the ground. Aircraft fly here to avoid the weather below.

> > > Manned balloon

Mount Everest Most meteors burn up when they enter the atmosphere, so it protects the Earth from their destructive effects.

THERMOSPHERE

The mesosphere is above the stratosphere, 30 to 50 miles (48 to 80 km) above the Earth. Shooting stars, or meteors, are seen here.

> ruys from one our nucce w pass un the Earth. Ozone is a kind of oxygen that protects the Earth from the harmful rays of the Sun. Without this laver, most living creatures would die.

Rays from the Sun have to pass through

Weather Concorde balloon

> The atmosphere lets only half the Sun's rays reach the Earth. Some are absorbed and the rest are reflected back into space.

Satellite. in orbit

This is a space shuttle. Space shuttles can be used to carry out experiments in space.

What Air Is Made Of This bunch of balloons shows the amounts of different gases in the atmosphere. The blue balloons are nitrogen and the red ones, oxygen. The white balloon is all the other gases.

The thermosphere is a layer of very thin air found above the mesosphere. It goes from 50 to 290 miles (80 to 467 km) above the ground. Auroras are bands of ______ flickering, colored light high in the atmosphere. They are usually seen near the North and South Poles as beautiful, shimmering patterns of green, purple, and gold.

Breathless

The higher you go, the less oxygen there is in the air. This is why mountain climbers need to wear oxygen masks.

Breath of Life

We cannot see the air we breathe, but it is vital to us. Without it, we would die. Air is made up of a mixture of gases, including oxygen. The oxygen comes from plants and trees, such as the ones shown in this tropical rain forest in Costa Rica.

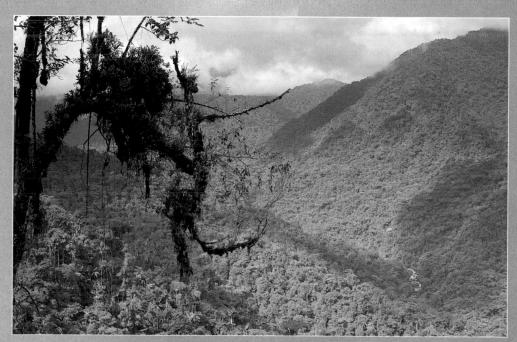

CLIMATE

What is it like today where you are? Is it cold, hot, snowy, foggy, windy, or a mixture of some of these? Does the weather stay much the same year-round, or does it change with the seasons? Your answers will depend on where you live and on the Sun. Both play important parts in making our climate.

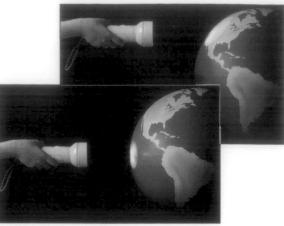

Hot and Cold

Imagine the flashlight is the Sun. When it shines on the middle of the Earth, it makes a small, hot patch. At the top and bottom, the patch spreads out over a bigger area, so it heats the land less.

How Hot Is It?

Places on the equator are always hot. As you move away from the equator, north or south, it gets colder and colder until you reach the North or South Pole. The bands of color show how hot or cold it is in different parts of the world.

Always hot

Hot in summer, warm in winter Hot in summer, mild in winter Warm in summer, cold in winter Cool in summer, cold in winter Cold all the time

Hottest

Death Valley in the U.S. Southwest is where the hottest temperatures have been recorded.

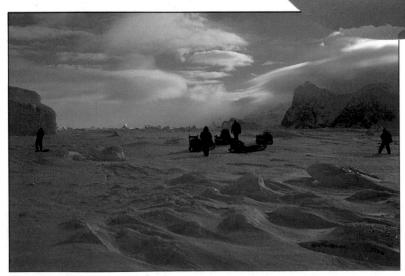

Coldest

Antarctica is the coldest place on Earth. Snow and ice cover the ground all year.

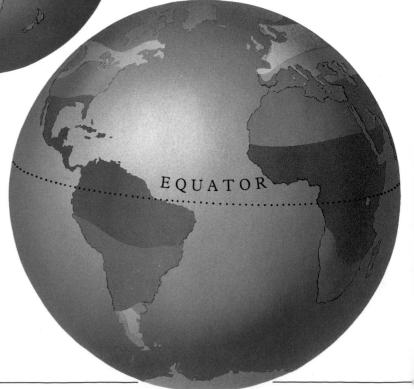

Spring in the North, autumn in the South

Winter in the North, summer in the South

Summer in the North, winter in the South

Times of the Year

Autumn in the North, spring in the South

The seasons change because the Earth is tilted. As it goes around the Sun, it is summer in the half near the Sun and winter in the half farthest away.

How Wet Is It?

The wettest places on Earth are around the equator, where it rains heavily nearly every day. Generally, it rains less as you travel toward the North or South Pole. Match the colors on the map to the chart and find out how wet or dry each area is.

Sun

Heavy rain every month Light rain every month Heavy seasonal rain Light seasonal rain Hardly ever rains Snows a lot

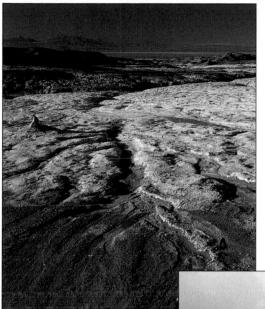

Driest

On average, the Atacama Desert is the driest of all the deserts in the world. Less than .04 inches (1 mm) of rain falls here each year. The desert is in Chile, in South America.

Wettest

Tutunendo, in Colombia, South America, is the wettest known place. It gets about 36 feet (11 m) of rain every year.

Disaster in the Making? Many experts think that the climate is getting warmer. If it warms just a little, and enough of the ice at the Poles melts, low-lying land and cities will be flooded.

CLOUDS

Cirrus clouds are feathery_ and wispy. They are seen high up in the sky.

A cloud is made of billions of tiny drops of water so light that they float in the air, but it begins its life as moist air warmed by the Sun. Because warm air is lighter than cold air, it rises in the sky – just the same way as a hot-air balloon. In a rain cloud, the tiny drops of water join together. They become too large and heavy to float in the air and fall to the

ground as rain.

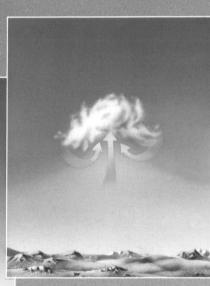

Up... The moist air rises up when it is heated by the Sun. The warmed, moist air floats up like bubbles.

(***)

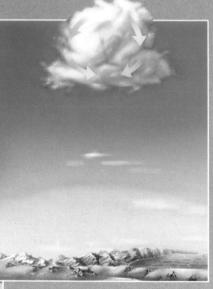

... and Away High in the sky, the temperature is cold. The warm air is cooled. It turns into a cloud of tiny drops of water. 10 miles (16.1 km)

8 miles (12.9 km)

Cirrocumulus

6 miles (9.7 km)

Altostratus

4 miles (6.4 km)

Altocumulus/

2 miles (3.2 km)

Stratocumulus_

Up... For clouds to be made, there must be warm, moist air.

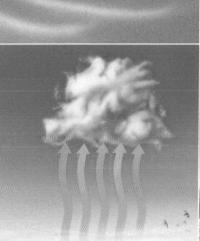

[']Cumulonimbus

Wet

As warm air flows over seas, lakes, and rivers, it picks up water from them.

Wetter The warm air also takes up water from plants and trees that grow on land.

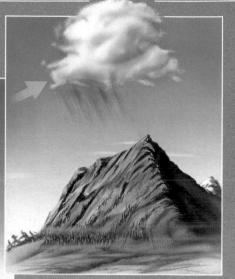

Wettest

When the warm, moist air rises (for example, over mountains), it hits cold air and turns into a cloud of tiny water droplets. These come together to make raindrops.

Cumulus clouds are puffy, white masses. They are found between cirrus and stratus clouds. Usually, they bring warm, dry weather.

> Stratus clouds look as if they are made up of layers. They are low down in the sky and bring wet, even stormy, weather.

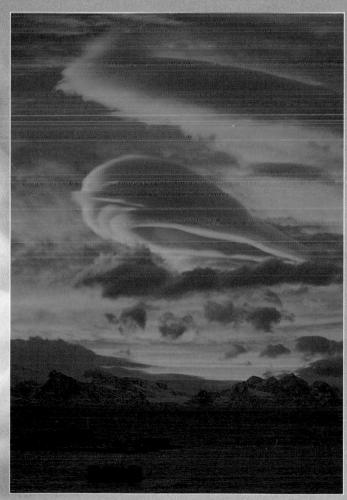

Is It a Bird? Is It a Plane? This strange shape looks like a spacecraft, but it is actually a lenticular cloud.

THUNDER AND LIGHTNING

Static Electricity When you take off a sweater, your head and the sweater rubbing together sometimes create static electricity.

A bolt of lightning is a giant spark of static electricity. It is the same sort of electricity that crackles when you run a comb through your hair. Static electricity is made by two things rubbing together. In the case of lightning, it is ice crystals and water drops rubbing against each other in a cloud. Lightning flashes inside a cloud as sheet lightning or from cloud to ground as forked lightning. As it does so, it sends out huge shock waves and makes the noise of thunder.

> Thunderclouds are very/ tall, puffy, and dark.

How Lightning Strikes

A flash of lightning is made up of a number of sparks that follow each other so quickly that they look like just one streak. These sparks go backward and forward in the cloud or between the cloud and the ground. Forked lightning_

Strange Behavior

Ball lightning looks like a round fireball and may be white, red, yellow, or blue. It tends to get into buildings through chimneys and escape under doors.

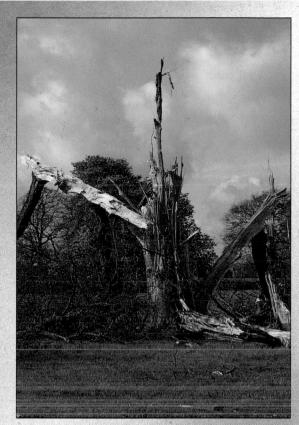

Direct Hit Fork lightning finds the quickest, easiest way to the ground. This is why trees and tall buildings are in such danger of being struck.

> As a lightning bolt flashes through the air, the air around it becomes five times as hot as the surface of the Sun.

The core of a flash of lightning may be as thin as half an inch (1.3 cm).

Full of Energy A bolt of lightning has enough energy in it to power a small town for a year.

WIND

Wind is air that is moving around. You can't see it, but you can feel it, and you can see what it does. Wind can be as gentle as a breeze that ruffles your hair and cools you down on a hot day – or as violent as a hurricane that rips up trees and buildings and flattens all in its path.

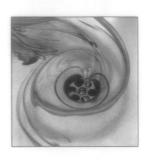

In a Spin

Water spins down a drain in a strong swirl with a hole in the middle. It goes down in a spin because the Earth is spinning. A hurricane does the same thing, only upward.

What Happens in a Hurricane

The top of the_ cloud is icy.

Clouds spread > out at the top.

Pointing into the Wind

Weather vanes swing around so that the front points into the wind, showing you the direction from which the wind is blowing. The hurricane sucks in – cool air, which takes the place of the hot air.

At the center of the spiral is a calm spot called the eye.

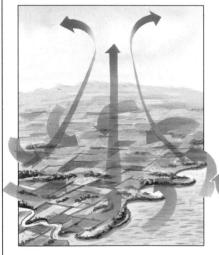

Why the Winds Blow The winds are made by

air rising or falling. When air is warmed by the Sun, it rises. Cool air is then drawn in to take the place of the warm air. When air is cool, it is heavy and sinks down, moving out in sweeping curves when it reaches the surface of the Earth.

Torrential rains fall around the eye.

Picking Up Speed

The Beaufort Scale tells you how fast a wind is blowing and how strong it is. It is based on the effect the wind has on such things as trees and houses. The strength of the wind is measured in forces from 0 to 12.

Force: 0–3; Strength: light breeze; Speed: 0–12 mph (0–19 km/h)

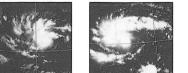

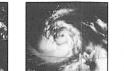

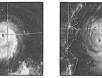

Weather Warning

These satellite photos from space show how a hurricane builds up. It starts where storms over the ocean come together in a big, powerful swirl.

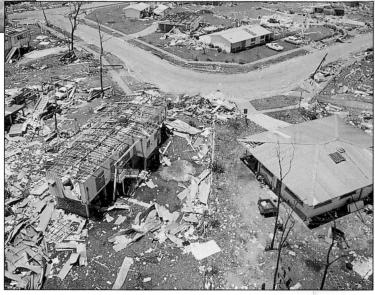

Torn Down Smashed buildings mark the path of a storm through Darwin, Australia.

> Some hurricanes may be almost 500 miles (805 km) across.

> > Hot air rises and spirals up around the eye.

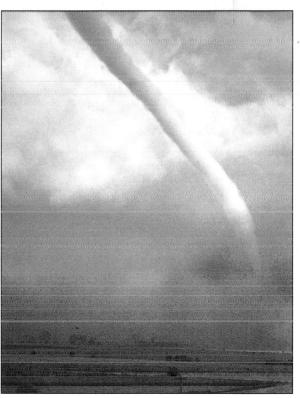

Destructive Force Tornadoes are whirling funnels of wind that suck trees, cars, and buildings into the air like a giant vacuum cleaner and then throw them to the ground.

Force: 10–11; Strength: storm; Speed: 55-73 mph (89-117 km/h)

Force: 12; Strength: hurricane; Speed: 74 mph and above (118 km/h)

Force: 4-5; Strength: moderate wind; Speed: 13–24 mph (20–38 km/h)

Force: 6–7; Strength: strong wind; Speed: 25-38 mph (39-61 km/h) mph (62-88 km/h)

Force: 8–9; Strength: gale; Speed: 39-54

TAKING CARE OF THE EARTH

Earth is an incredible place teeming with animals, insects, fish, birds, plants, and people. Like a Noah's Ark in space, it provides a home for all. It gives us shelter,

warmth, food, water, and the air we breathe.

Like Noah's boat, our ark needs looking after. Its air, oceans, and rain need to be cleaned up, its forests saved, and its soil protected from harmful chemicals. It is a big task, but we Earthlings can do it.

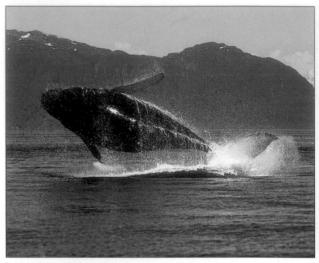

Saving the Seas Cleaning up the pollution in our oceans will help save the world's underwater creatures from becoming extinct.

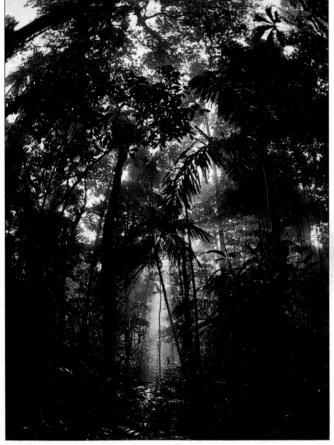

Trees of Life

If we stop cutting down the tropical rain forests, millions of species of birds, animals, insects, and plants will keep their homes.

Driving Force

In the future, cars may run on solar power, using energy from the Sun. Other alternatives to gasoline include fuels made from plants such as sugar cane.

Cleaning the Air

Cutting down on the amount of chemicals pumped out by factories and car exhaust pipes will improve the quality of the air we breathe.

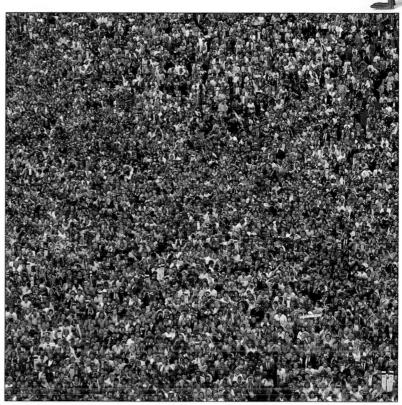

Living Space

Our planet is home to billions of people. We need to make sure that it is not swamped by sheer weight of numbers.

How You Can Help Recycle bottles, cans, paper, and aluminum foil. Avoid using plastic packaging. Save energy by switching off lights when they are not needed. When possible, use paper that has been recycled.

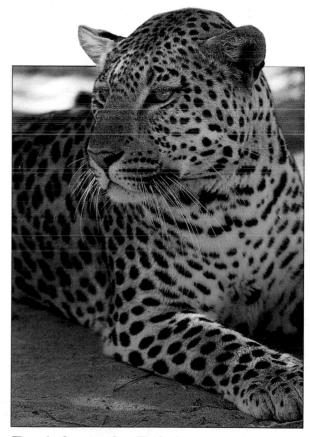

Back from the Brink If we protect wildlife from being hunted and preserve the places it lives, animals, such as this leopard, will be saved from extinction.

GLOSSARY

Atmosphere A blanket of gases that surrounds a planet or moon.

Butte A small, flat-topped hill found in deserts.

Chimney rock Hard rock in a desert that has been worn into a pinnacle.

Climate The average weather in an area.

Coastline The place where land and ocean meet.

Continent One of seven large areas of land on Earth.

Coral reef A mass of coral, the top of which is very near the ocean's surface.

Cuesta A step of hard rock found in deserts.

Current Movement in a particular direction by ocean or river water.

Delta A mass of sand, mud, and rock fragments formed at a river's mouth.

Desert Any place where less than 10 inches (25 cm) of rain falls a year.

Acknowledgments

Photography: Tina Chambers, Geoff Dann, Steve Gorton, James Stevenson. Illustrations: Jim Channell, Roy Flooks, Mick Gillah, Keith Hume. Models: Donks Models. Thanks to: H. Samuel Ltd., Truly Scrumptious Child Model Agency.

Reader's Digest Fund for the Blind is publisher of the Large-Type Edition of *Reader's Digest*. For subscription information about this magazine, please contact Reader's Digest Fund for the Blind, Inc., Dept. 250, Pleasantville, N.Y. 10570. **Dune** A heap of sand blown into a hill by wind.

Earthquake Sudden movements in the Earth's crust that cause violent shaking.

Equator An imaginary line around the Earth's middle.

Estuary The place where a river goes into the ocean.

Flash flood A sudden, violent flood in a desert.

Focus The place under the Earth where an earthquake starts.

Fossil Animal or plant remains that have been preserved in rock.

Galaxy A huge "island" of stars in space.

Glacier A mass of ice moving slowly down a mountain.

Globe A sphere that has a map of the world drawn on it.

Gorge A deep, narrow valley cut by a river.

Hurricane A strong wind that forms over oceans in tropical areas.

Lava Red-hot, melted rock that erupts from a volcano and flows onto the Earth's surface.

Magma Melted rock under the Earth's surface.

Mantle The layer of the Earth which is below the crust.

Mercalli Scale A way of measuring how much the surface of the Earth shakes during an earthquake.

Mesa A large, flat-topped, steep-sided area of land in a desert.

Moon A ball of rock in space that goes around a planet.

Ocean A huge, salty body of water. Also called a sea.

Planet A large round object that orbits a star.

Satellite A moon or other object in space that goes around a planet or star.

Season A time of the year with a special climate.

Sediment Sand, mud, and gravel moved from one place to another by wind, water, or ice.

Spit A new piece of land made of sand, mud, and pebbles built by the waves.

Stack A rock pillar left standing in coastal waters when the top of an arch falls in.

Tide The regular rising and falling of the ocean.

Tornado A whirling funnel of wind.

U-shaped valley The channel worn away by a glacier moving downhill.

V-shaped valley The channel worn away by a river as it flows downhill.

Volcano The place where hot, liquid rock breaks through the Earth's crust.

Weathering The breaking up of rocks by wind, rain, and ice.

Picture credits

Ancient Art & Architecture Collection: 22; Ardea: François Gohier 46r, Clem Haagner 11b, 47b, D. Parer & E. Parer-Cook 11t; Biofotos: Heather Angel 31cr, Bryn Campbell 27, Brian Rogers 31cra; Bruce Coleman: Stephen J. Kraseman 47tl; Frank Lane Picture Agency: Australian Information Service 45tr, Ray Bird 43r, R. Jennings 43l, S. McCutcheon 30clb; G.S.F. Picture Library: 3, 14, 15, 25tr; Rafn Hafnfjord: 13; Robert Harding Picture Library: 25tl, 45b; Image Bank: James H. Carmichael 37; Japan Meteorological Agency/National Meteorological Library, Bracknell: back cover, 45tl(1-5); Mountain Camera: John Cleare 36; NASA: 6t & b; NHPA: A.N.T./Grant Dixon 39t, G.I. Bernard 46l; Oxford Scientific Films: Doug Allen 41, Stuart Bebb 18l, Martyn Colbeck 35c, Warren Faidley 42/43, Terry Middleton 25b; Dr. Chris Pellant: 28; Pictor: 1, 21, 33t; 40; Planet Earth Pictures: Rob Beighton 38c, G. Deichmann/Transglobe 35b, Hans Christian Heap 34, back cover, John Lythgoe 18r, Mike Potts 33b, K. Puttock 38b; Science Photo Library: ESA front cover, 4tl, 8tl, Geosphere Project, Santa Monica/Tom Van Sant 8cr, 9cl, Maptec International 8tr, NASA 8bl, 9tl & tr, 38t, National Snow & Ice Data Center 9cr, Claude Nuridsany & Marie Perennou 30tl, cla & bl, 31tr & br, David Parker 16, Sheila Terry 19r; South American Pictures: Tony Morrison 39b; John Massey Stewart: 23; ZEFA: 47tr, ALLSTOCK/W. McIntyre 19l, ALLSTOCK/Art Wolfe endpapers, A.P.L. 29b, DAMM 32, Knight & Hunt 35t, Rossenbach 29t.

 $\begin{array}{lll} t-\textbf{top} & l-\textbf{left} & a-\textbf{above} & cb-\textbf{center below} \\ b-\textbf{bottom} & r-\textbf{right} & c-\textbf{center} & clb-\textbf{center left below} & crb-\textbf{center right below} \end{array}$

INDEX

A

Allosaurus 22 amber 23 Antarctica 27, 38 Apatosaurus 22, 23 Arctic 27 ash 14, 15 asteroid 6 astronaut 8 atmosphere 36–37, 48 auroras 37

В

ball lightning 43 beach 28 Beaufort Scale 44–45 block mountain 11 butte 34, 48

C

calcite 20, 24, 25 canvons 26 caves 24-25, 28 chimney rock 34, 48 cliffs 26 climate 38-39, 48 clouds 40-41 cirrus 40, 41 cumulus 41 stratus 41 coal 23 coastlines 28-29, 48 comet 6 conglomerate 18 continents 8, 9, 11, 12, 13, 48 coral 29, 48 core 10 crater 14 crust, Earth's 10-11, 12, 14, 17, 18, 19 crystals 20 cuesta 34, 48 currents 26, 27, 48

Γ

delta **33**, deposits **33** deserts **34–35**, **39**, diamond **20**, dinosaur **22**, downfold **10** dunes 29, 34, 35, 48 barchan 34 seif 34 star 34 tail 34

E

Earth 6, 7, 8, 9, 12, 13, 24 earthquakes 12, 13, 16–17, 48 electricity 42 epicenter 17 Equator 38, 39, 48 estuary 29, 48

F

fault **10, 16** feldspar **20** focus **17, 48** fork lightning **43** fossils **22–23, 48**

G

galaxy 6, 48 gems 21 glaciers 27, 30–31, 32, 48 globe 13, 48 gold 21 gorge 25, 33, 48 granite 19, 20 gypsum 20, 21

Η

headland 28 hematite 20 hot springs 14 hurricane 44, 45, 48

I

icebergs 27 igneous rocks 18, 19 intensity 17 iron ore 20 islands 26, 27 T

J Jupiter 6, 7

Ι

lava 12, 14, 15, 18, 25, 48 lightning 42–43 limestone 18, 24, 25

М

12

magma 15, 18, 19, 48 mammoth 23 mantle 10, 18, 48 map 9

marble 19 Mars 6, 7 marsh 29 meander 33 Mercalli Scale 17, 48 Mercury 6, 7 mercury 20 mesa 34, 48 mesosphere 36 metals 20, 21 metamorphic rocks 18, 19 meteor 36 mica 20 Milky Way 6 minerals 20-21, 24 Moa 23 Mohs Scale 20 Moon 6, 48 mountains 10, 12, 18, 19, 32 mud flats 29

N

Neptune 7 nitrogen 37 North Pole 8, 38, 39

0

obsidian 19 oceans 8, 9, 26–27, 46, 48 oil 23 orbit 6 ores 20 outwash fan 35 overfold 10 oxbow lake 32, 33 oxygen 36, 37 ozone 36

Р

pebbles 28, 29 pipe rock 34 planets 6, 7, 48 plate 12–13, 17 Pluto 7 pollution 46 Pompeii 22 pothole 24

Q

quartz 20, 21 R

rain forests 37, 46 rainwater 24, 25 ravine 35 recycling 47 red sandstone 18 ridge 27 rivers 18, 32–33 rocks 18–19, 20

S

sand 28, 29, 34, 35 sapphire 21 Saturn 7 sea 8, 18, 28, 29, 46 seasons 39, 48 sediment 32, 48 sedimentary rocks 18, 19 shock waves 17 silver 21 solar power 46 Solar System 6 South Pole 8, 38, 39 space 6, 7, 8, 9 spit 29, 48 stalactites 24 stalagmites 25 stratosphere 36 Sun 6, 7, 46

Τ

thermosphere **36**, **3**thunder **42–43** tides **26**, tornado **45**, troposphere tsunami **16**, **1**

U

universe 6 upfold 10 Uranus 7

V

valley rift 11 U-shaped 30, 31, 48 V-shaped 32, 48 Venus 6, 7 Vesuvius 22 volcanoes 12, 14–15, 18, 19, 27, 48

W

waterfall 32 waves 26, 28, 29 weathering 18, 19, 48 weather vane 44 winds 18, 19, 44–45